WHAT TO DRAW and HOW TO DRAW IT

by E·G·LUTZ

WHAT TO DRAW and HOW TO DRAW IT

by E·G·LUTZ

LOM ART

INSTRUCTIONS

In drawing from this book, copy the last diagram, or finished picture, of the particular series before you.

The other diagrams—beginning with number one, then number two, and so on—show how to go on with your drawing. They give the order in which to make the various strokes of the pencil that together form the completed picture. The dotted lines indicate where light lines are drawn that help in construction—that is; getting proportions correctly, outlining the general form, or marking details in their proper places. Do not press hard on the pencil in making these construction lines, then they can be erased afterwards.

Use pencil compasses for the circles, or mark them off with buttons or disks.

To Draw a Five-Pointed Star

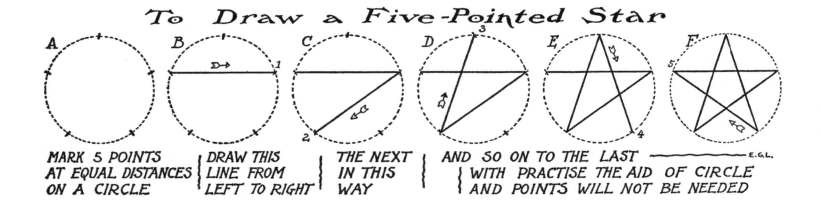

MARK 5 POINTS AT EQUAL DISTANCES ON A CIRCLE | DRAW THIS LINE FROM LEFT TO RIGHT | THE NEXT IN THIS WAY | AND SO ON TO THE LAST — WITH PRACTISE THE AID OF CIRCLE AND POINTS WILL NOT BE NEEDED

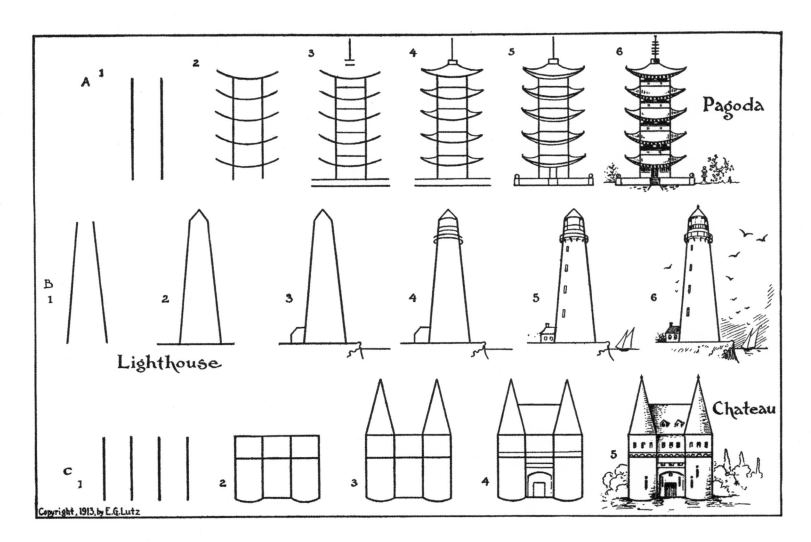

Pagoda

Lighthouse

Chateau

Tent

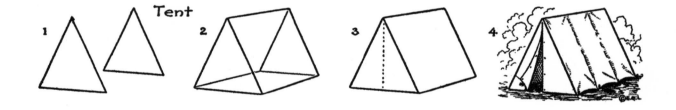

1 2 3 4

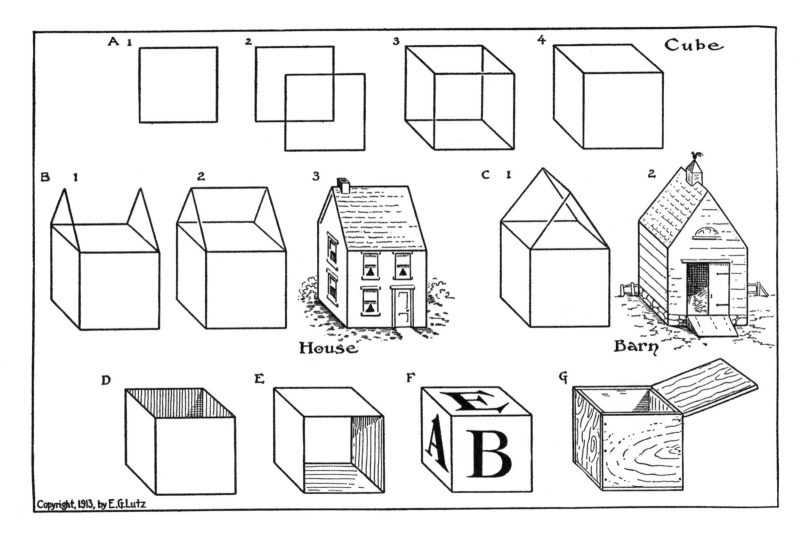

A 1 2 3 4 Cube

B 1 2 3 House

C 1 2 Barn

D E F G

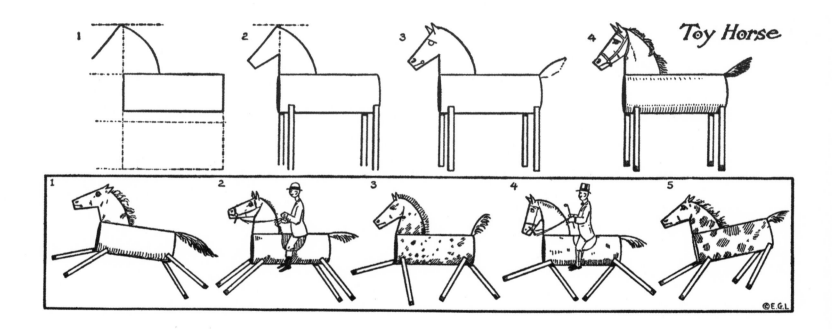

Toy Horse

©E.G.L.

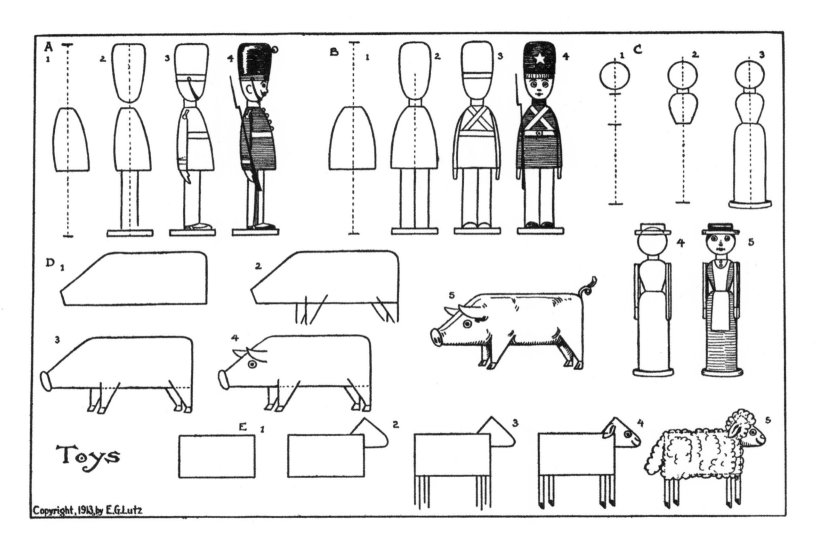

Toys

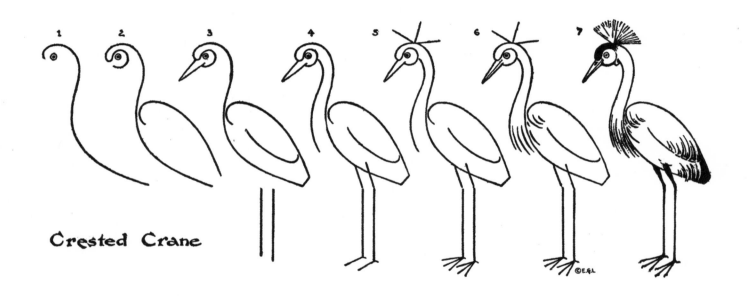

Crested Crane

14

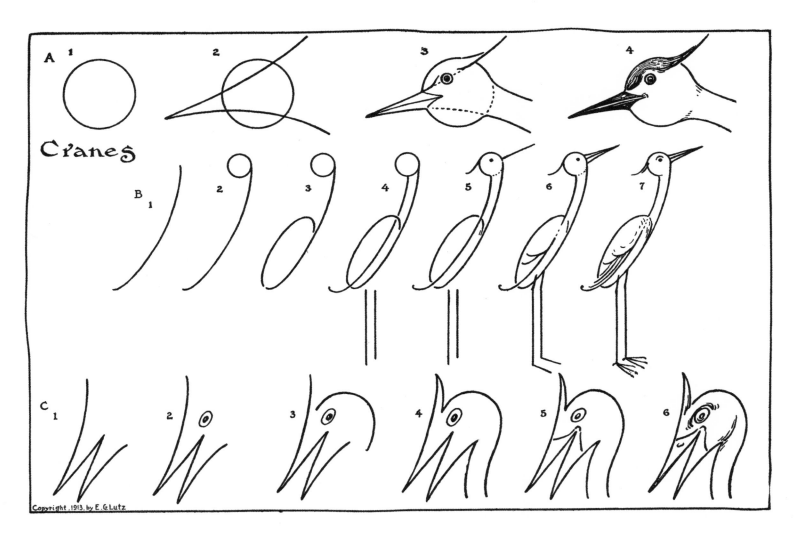

Cranes

15

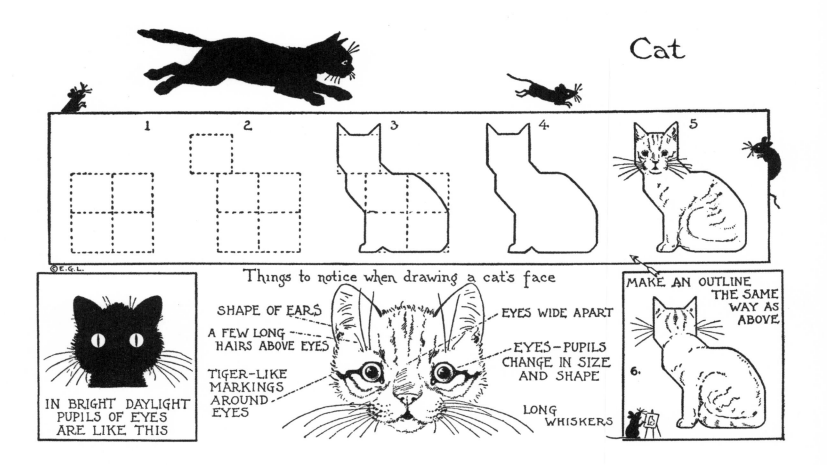

Cat

1
2
3
4
5

© E.G.L.

Things to notice when drawing a cat's face

SHAPE OF EARS

A FEW LONG HAIRS ABOVE EYES

TIGER-LIKE MARKINGS AROUND EYES

EYES WIDE APART

EYES—PUPILS CHANGE IN SIZE AND SHAPE

LONG WHISKERS

IN BRIGHT DAYLIGHT PUPILS OF EYES ARE LIKE THIS

MAKE AN OUTLINE THE SAME WAY AS ABOVE

6.

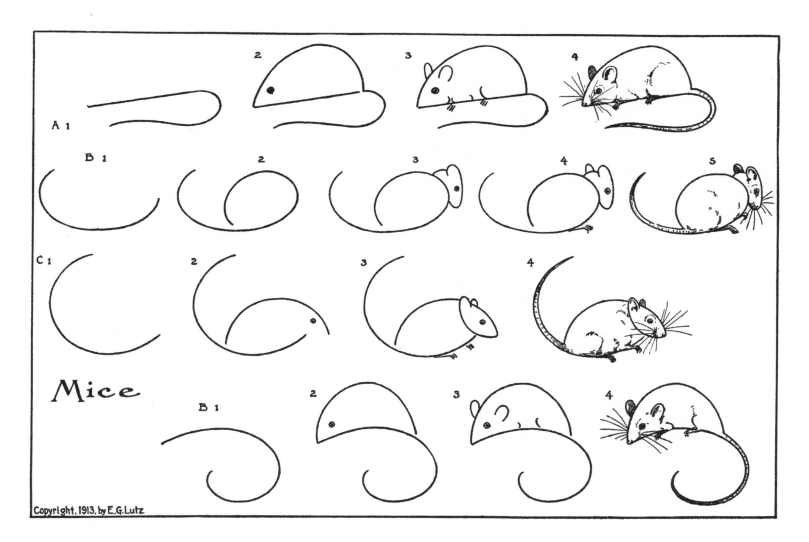

Mice

17

CURIOUS FISHES

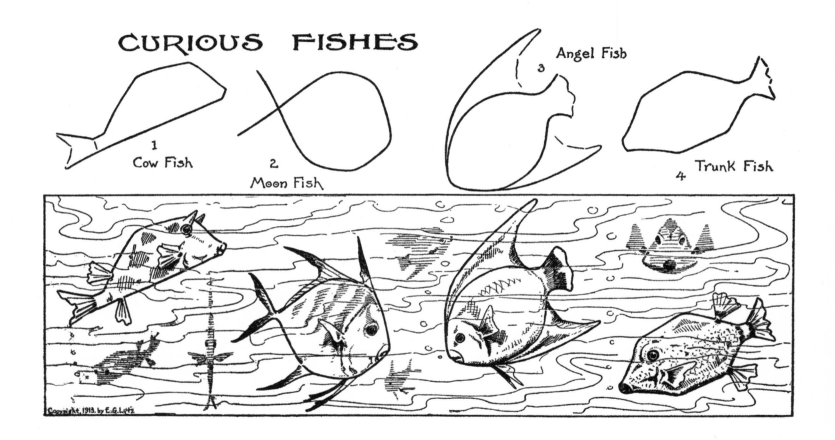

1 Cow Fish

2 Moon Fish

3 Angel Fish

4 Trunk Fish

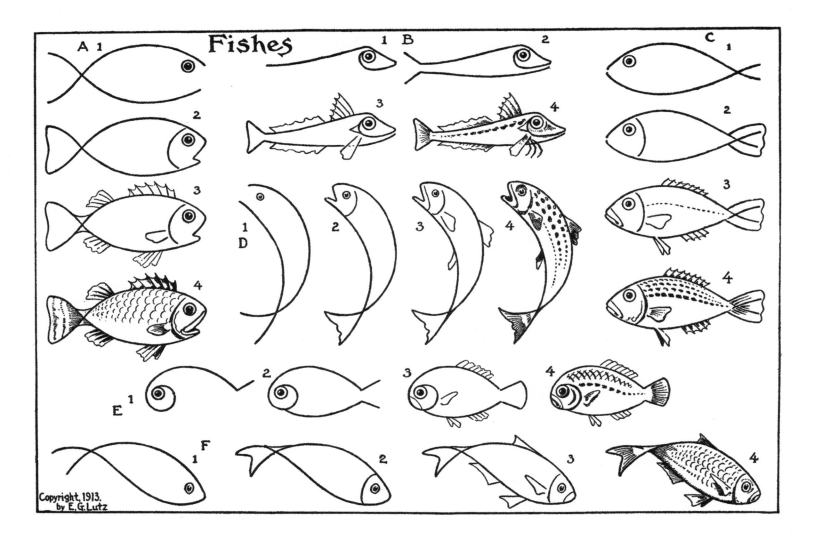

19

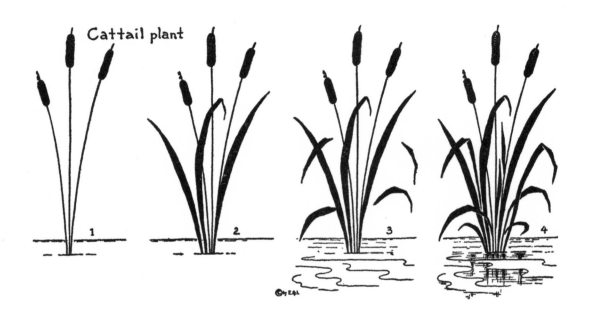

Cattail plant

1

2

3

4

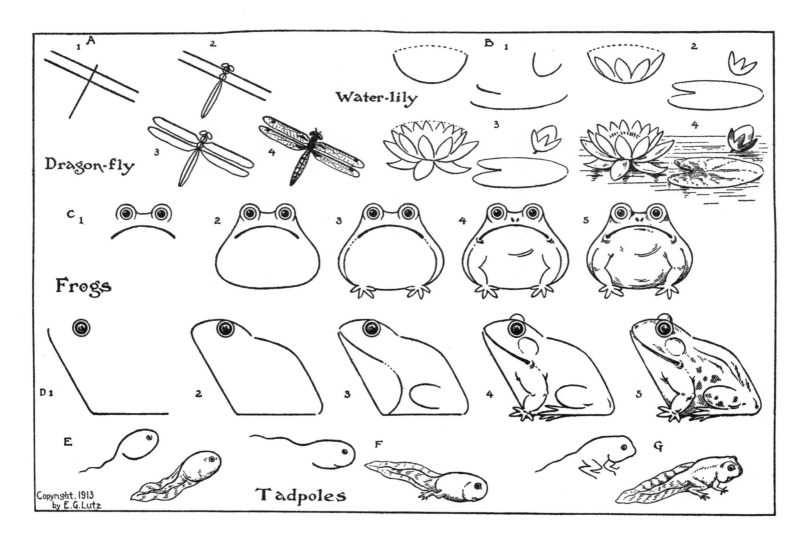

A

1 2

Dragon-fly 3 4

Water-lily

B 1 2

3 4

C 1 2 3 4 5

Frogs

D 1 2 3 4 5

E F G

Tadpoles

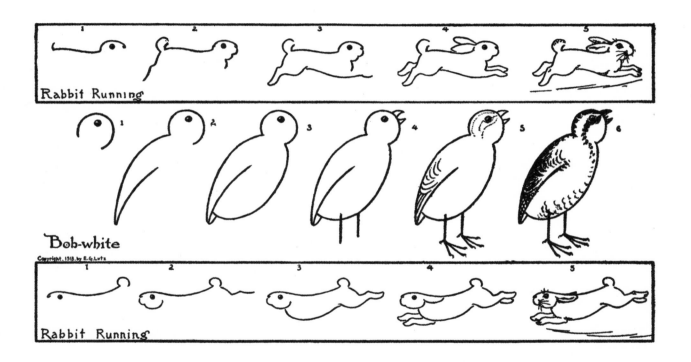

Rabbit Running

Bob-white

Copyright, 1913, by E.G.Lutz

Rabbit Running

22

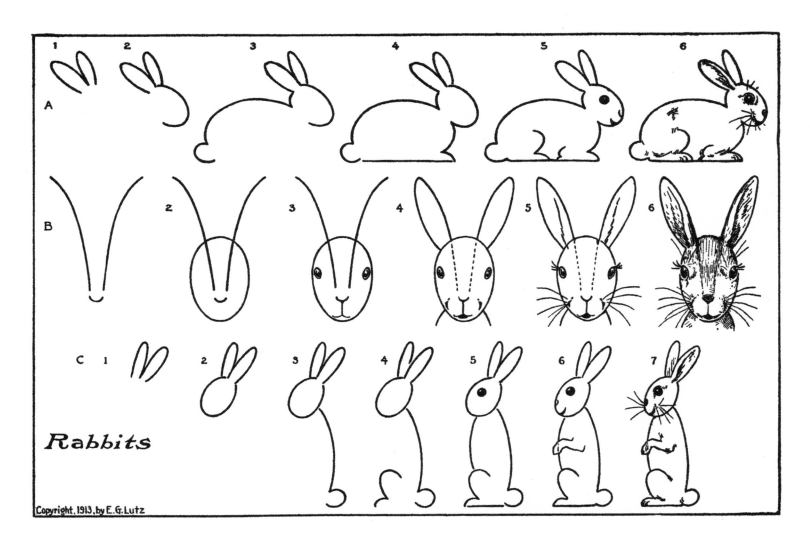

Rabbits

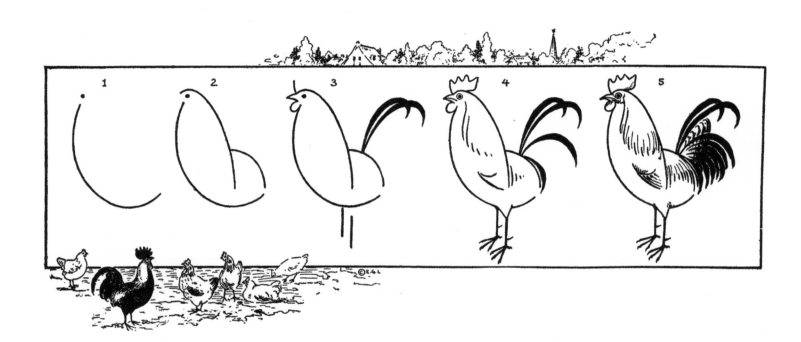

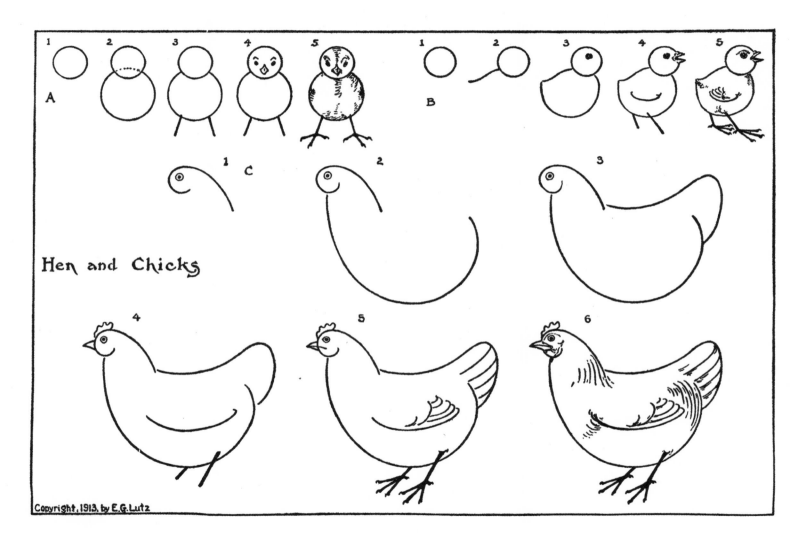

Hen and Chicks

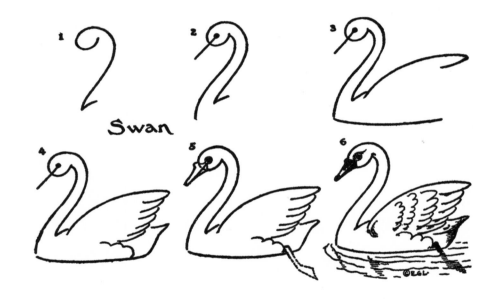

Swan

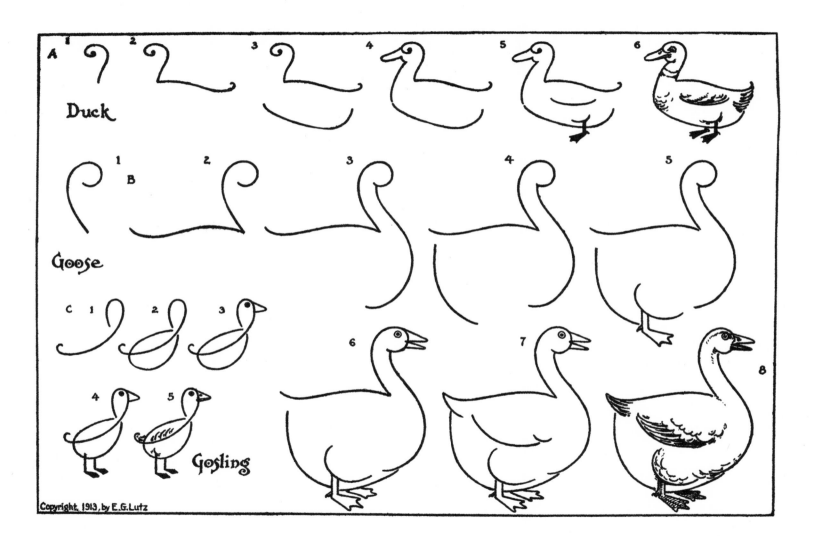

Duck

Goose

Gosling

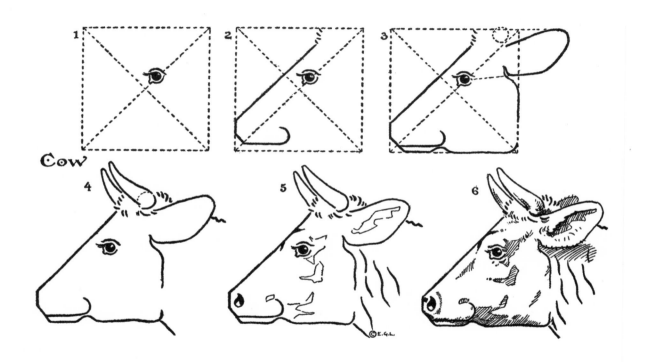

Cow

28

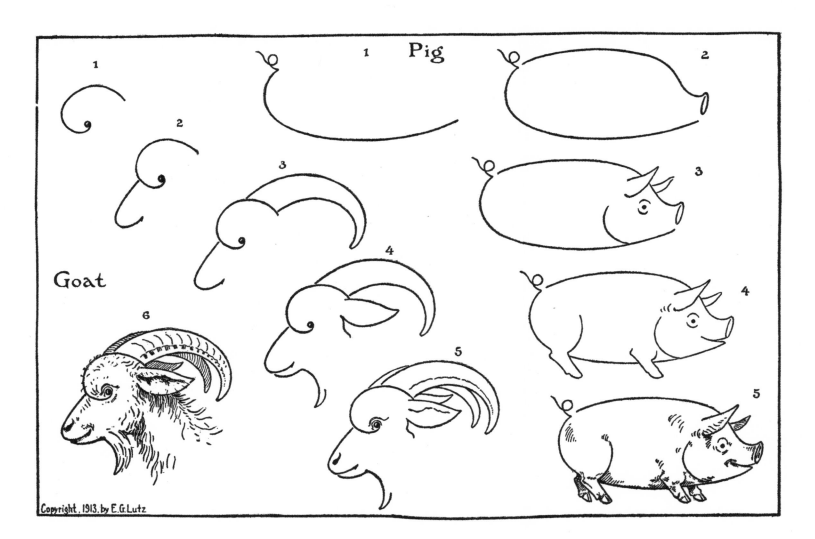

Pig

Goat

29

Bulldog

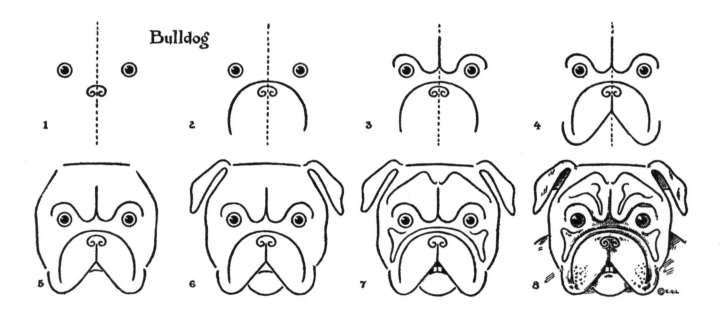

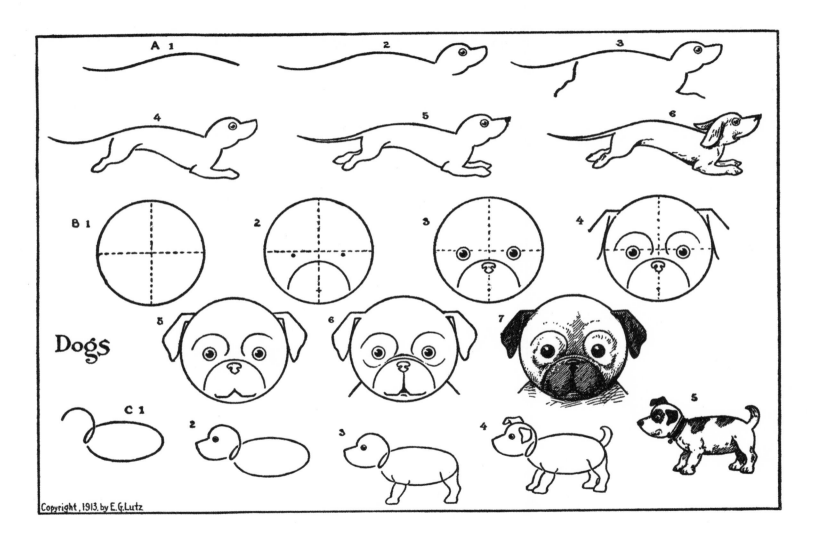

Dogs

31

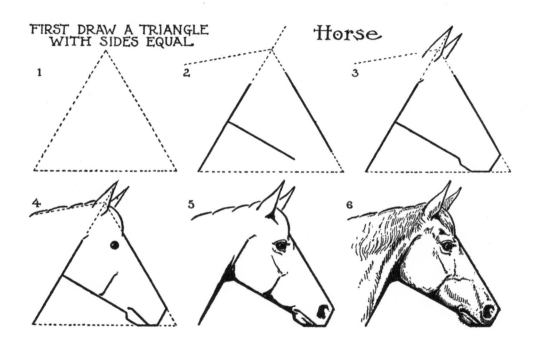

FIRST DRAW A TRIANGLE
WITH SIDES EQUAL

Horse

1

2

3

4

5

6

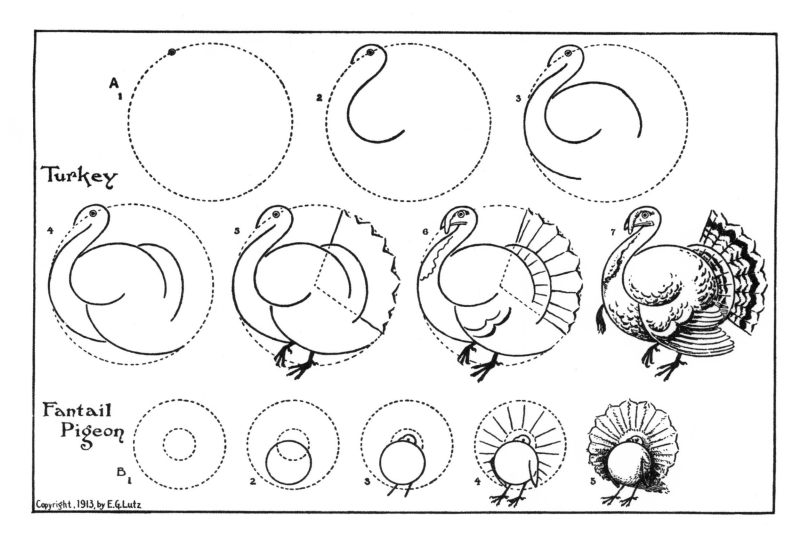

Turkey

Fantail
Pigeon

Humming-Birds

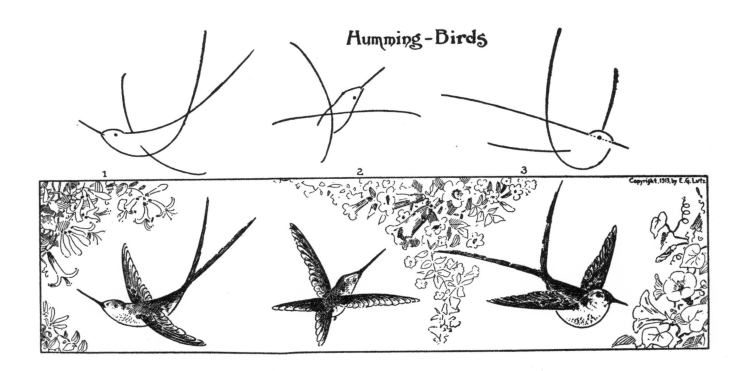

34

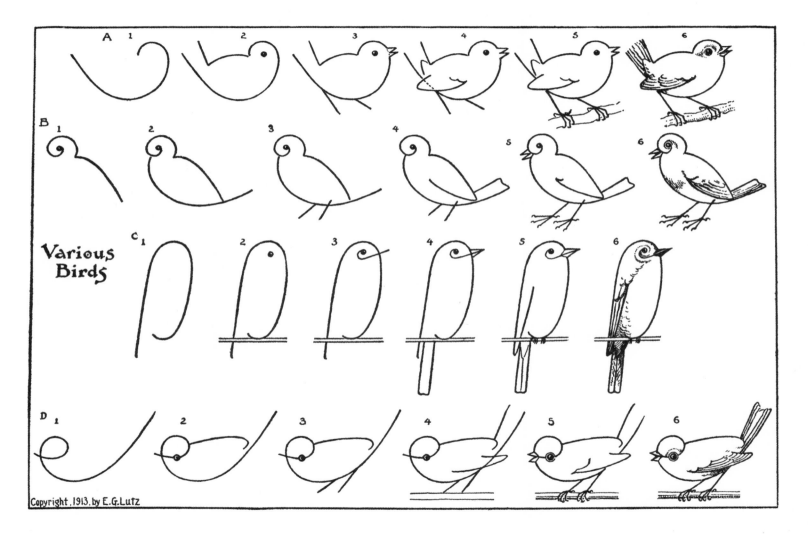

Various Birds

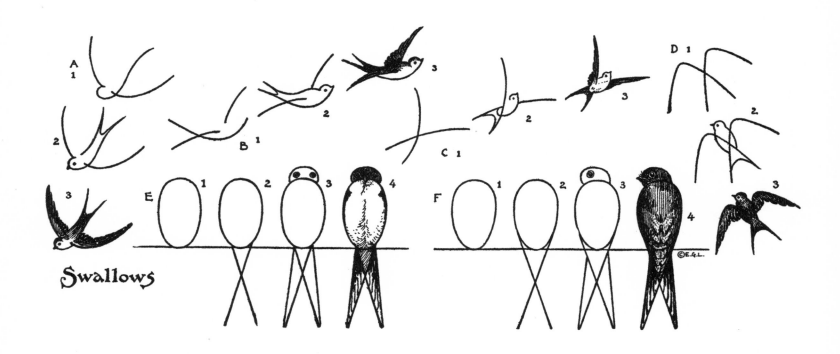

Swallows

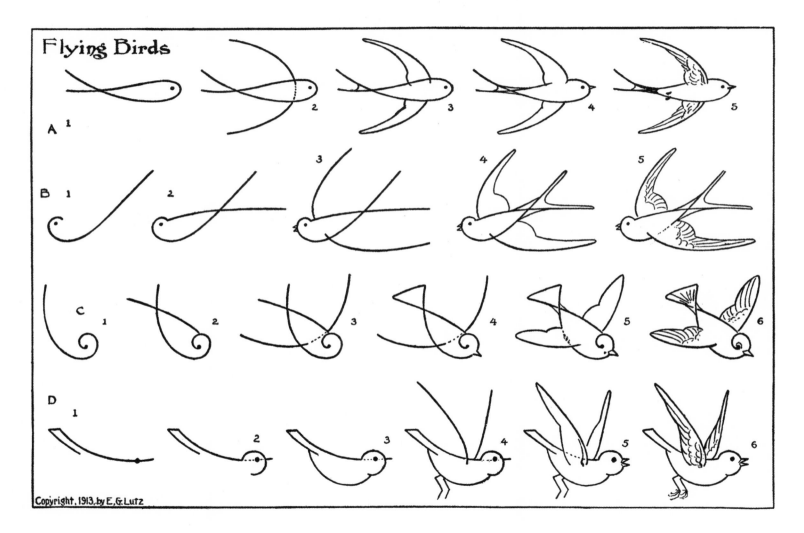

Flying Birds

A 1 2 3 4 5

B 1 2 3 4 5

C 1 2 3 4 5 6

D 1 2 3 4 5 6

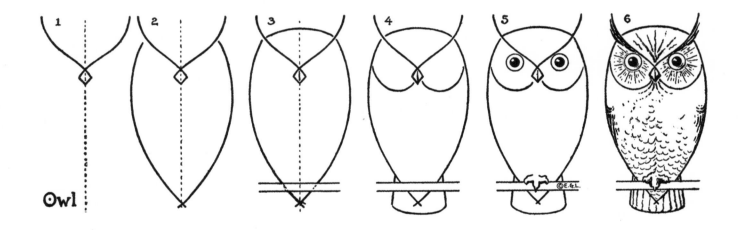

Owl

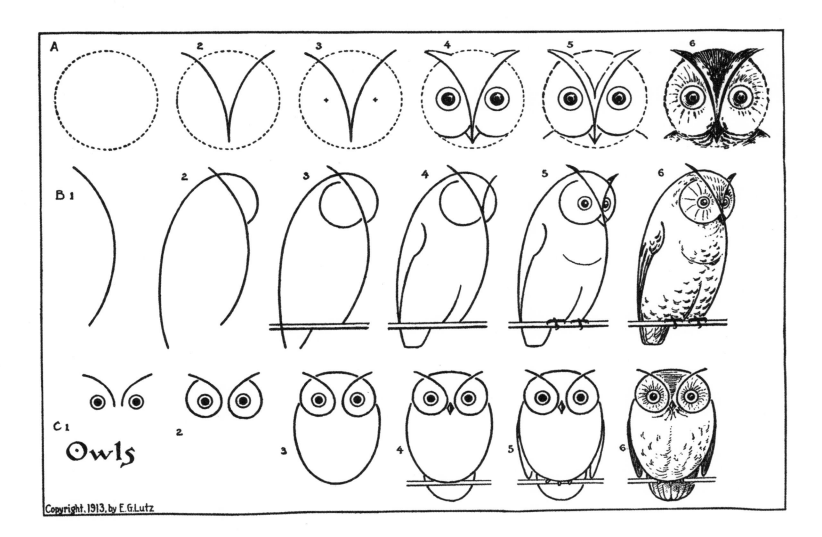

A
2
3
4
5
6

B 1
2
3
4
5
6

C 1
Owls
2
3
4
5
6

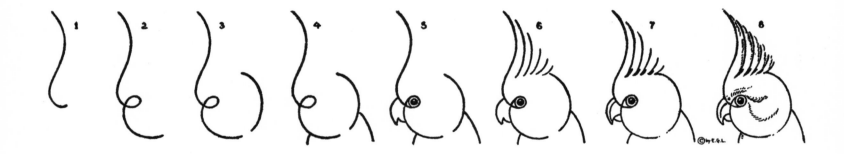

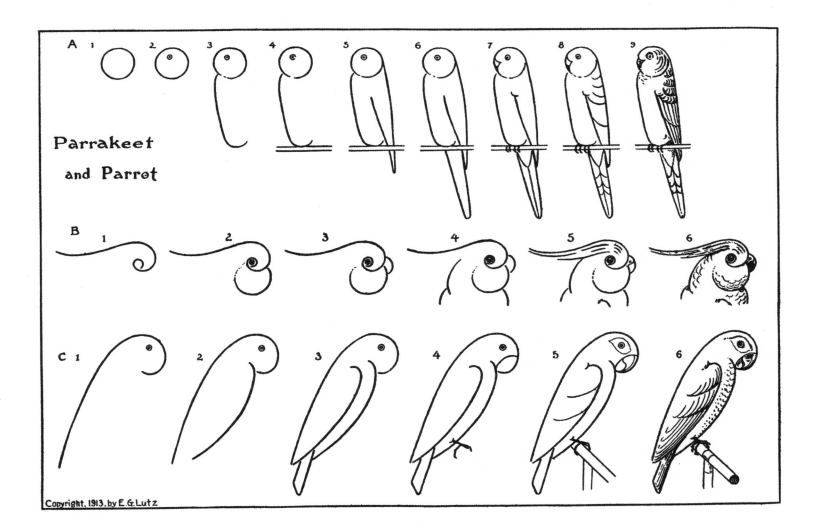

Parrakeet and Parrot

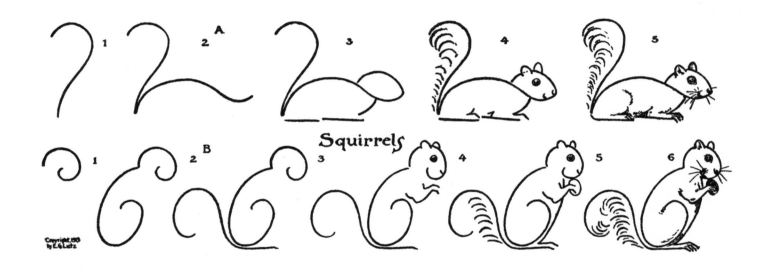

Squirrels

42

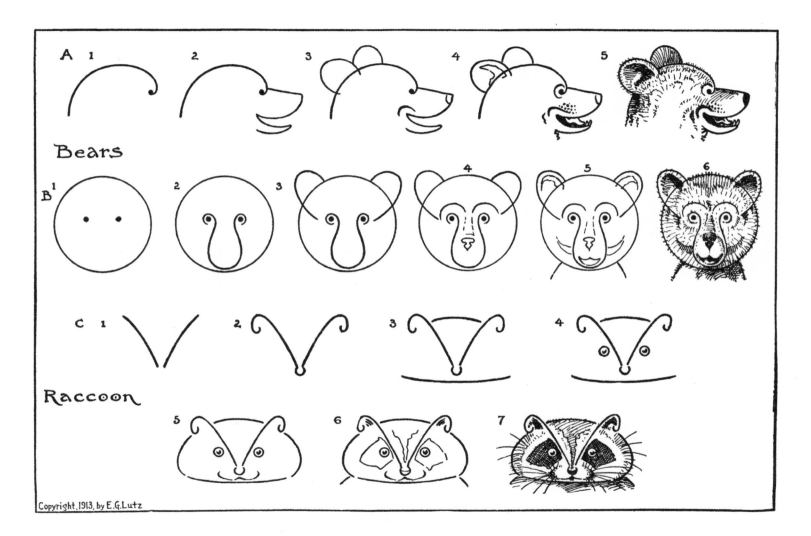

A 1 2 3 4 5

Bears

B 1 2 3 4 5 6

C 1 2 3 4

Raccoon

5 6 7

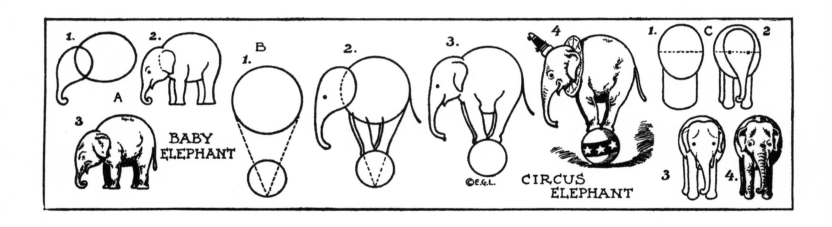

1. **2.**

A

3. BABY ELEPHANT

B **1.** **2.** **3.** **4.**

©E.G.L. CIRCUS ELEPHANT

1. C **2.**

3. **4.**

44

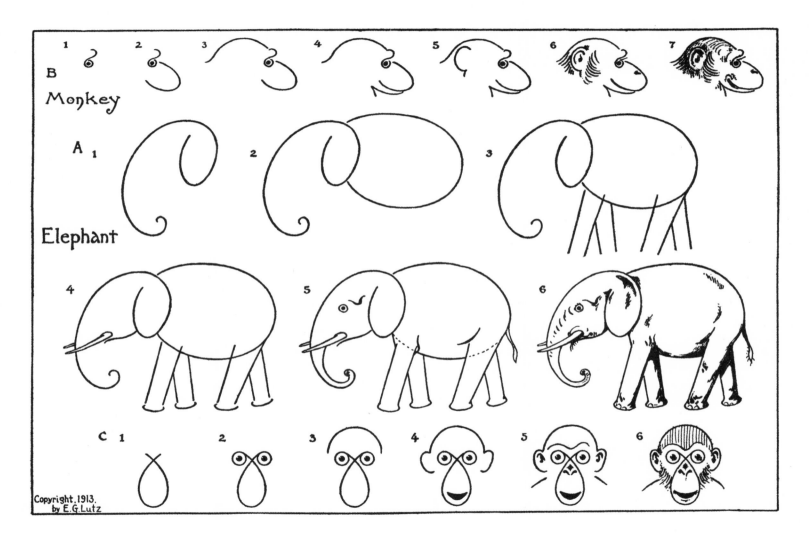

B
Monkey

A

Elephant

C

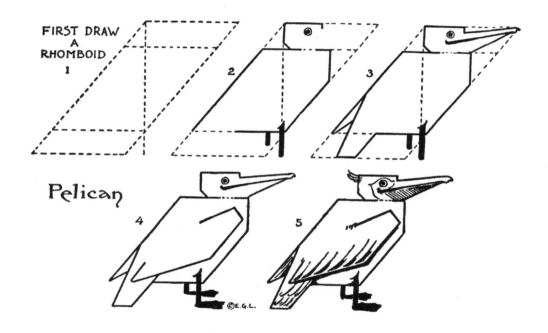

FIRST DRAW
A
RHOMBOID
1

2

3

Pelican

4

©E.G.L.

5

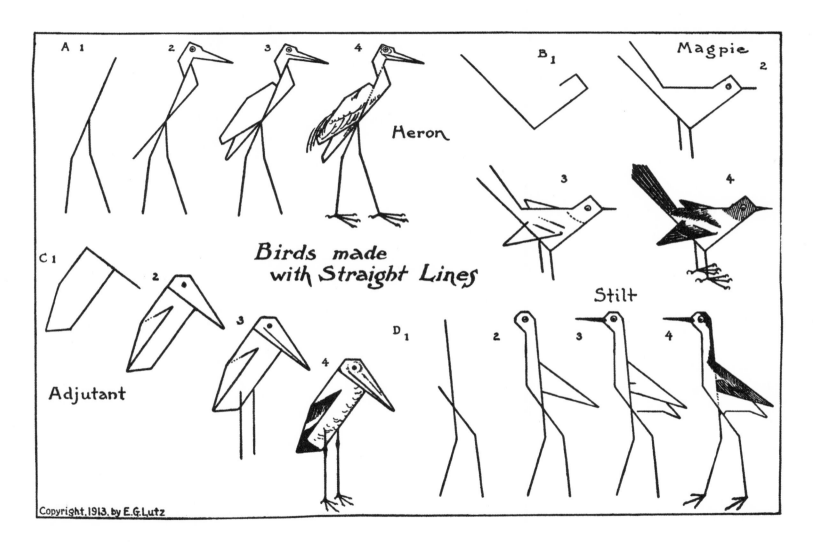

A 1　　2　　3　　4　Heron

B 1　Magpie 2　3　4　Stilt

C 1　2　3　4　Adjutant

D 1　2　3　4

Birds made with Straight Lines

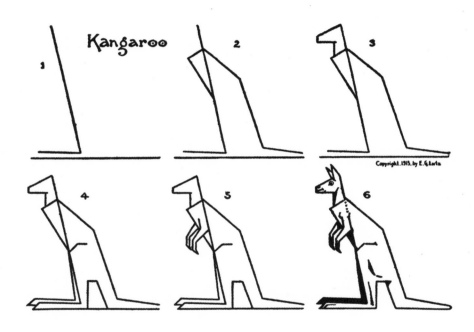

Kangaroo

48

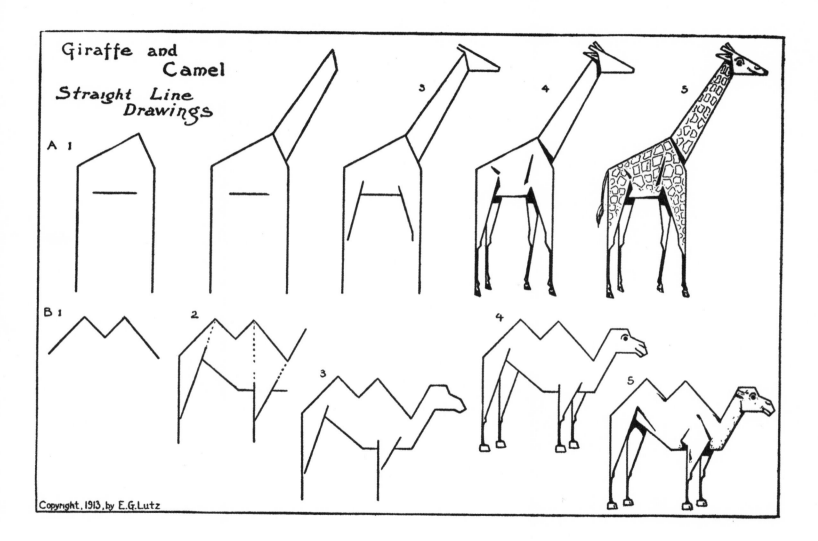

Giraffe and Camel
Straight Line Drawings

A 1 2 3 4 5

B 1 2 3 4 5

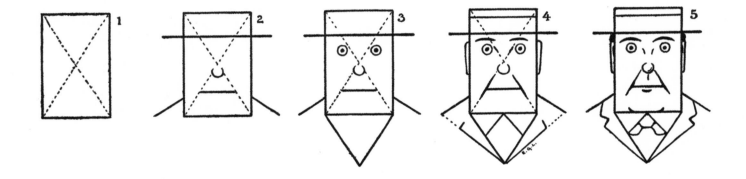

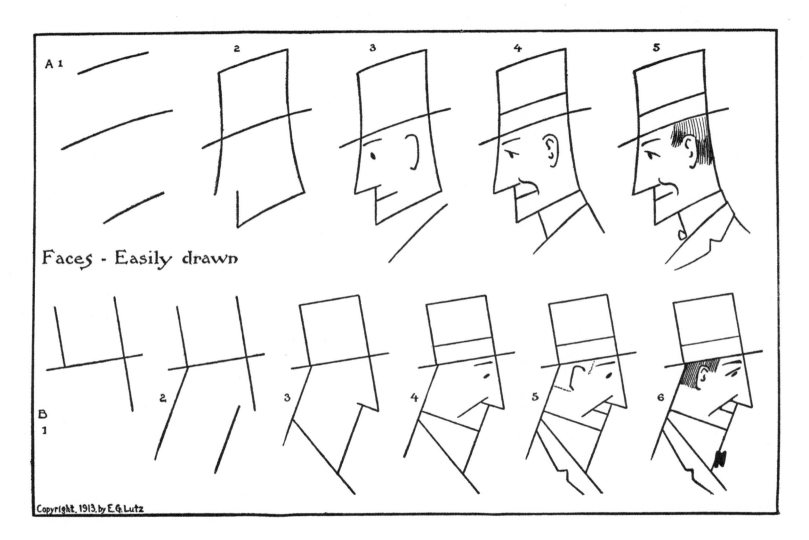

Faces - Easily drawn

51

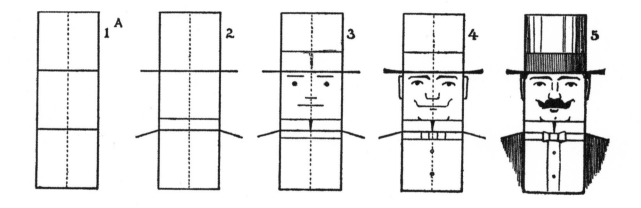

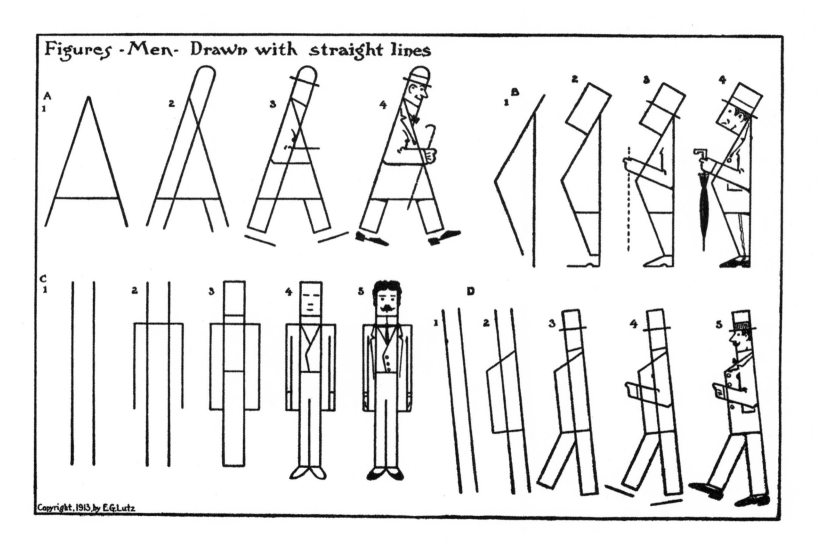

Figures -Men- Drawn with straight lines

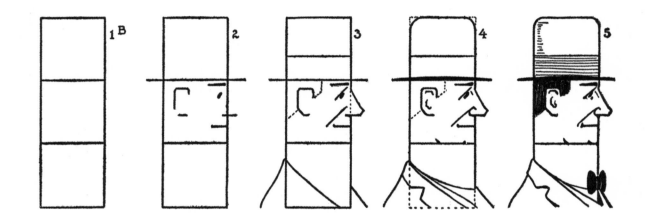

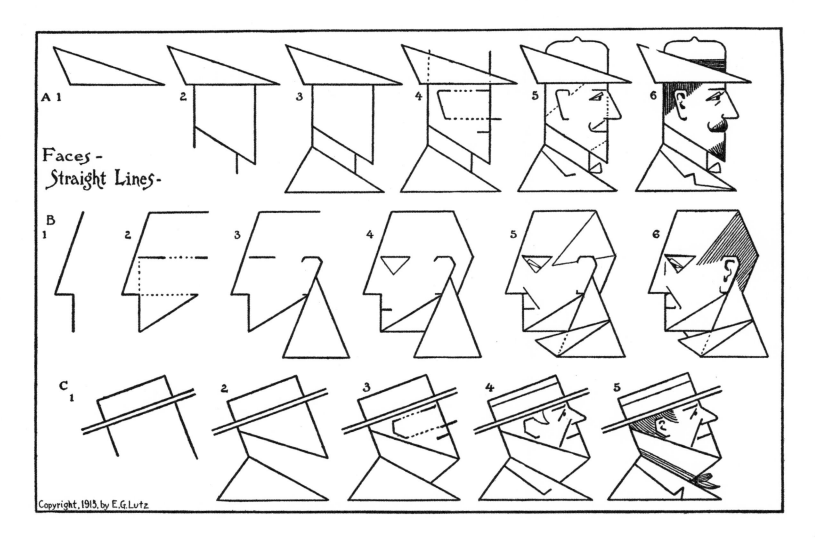

Faces -
Straight Lines -

A 1 2 3 4 5 6

B 1 2 3 4 5 6

C 1 2 3 4 5

The Clown's.
Droll
Face

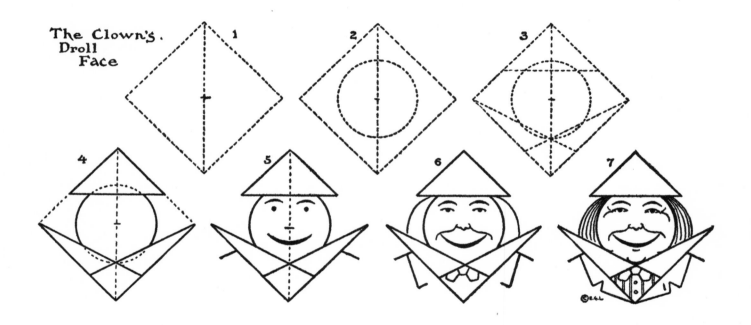

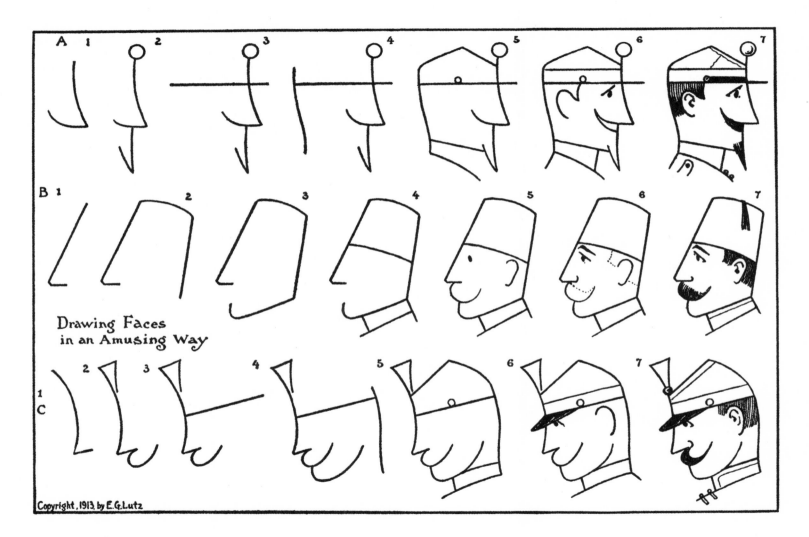

Drawing Faces
in an Amusing Way

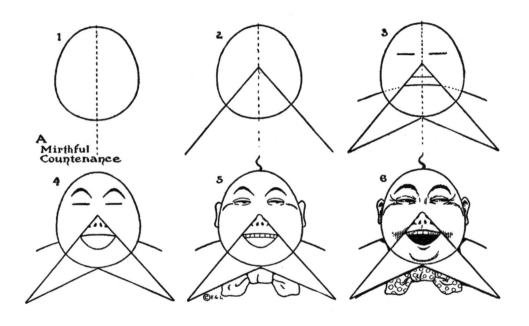

A
Mirthful
Countenance

58

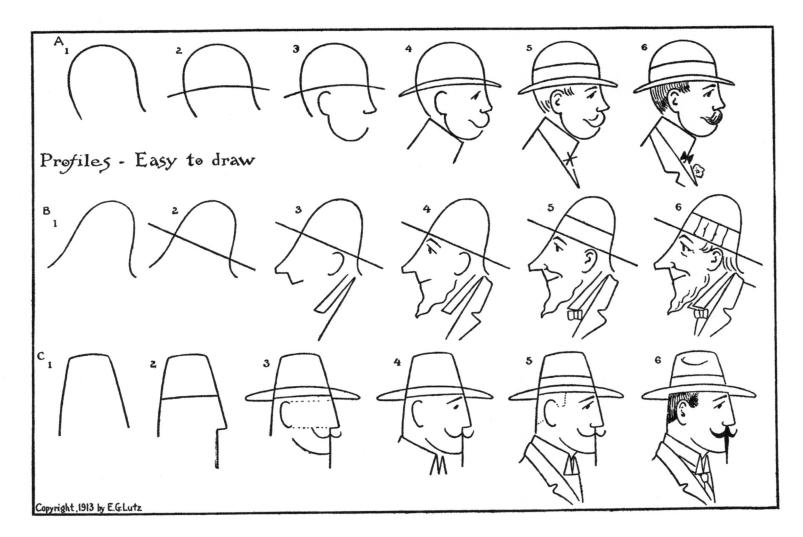

Profiles - Easy to draw

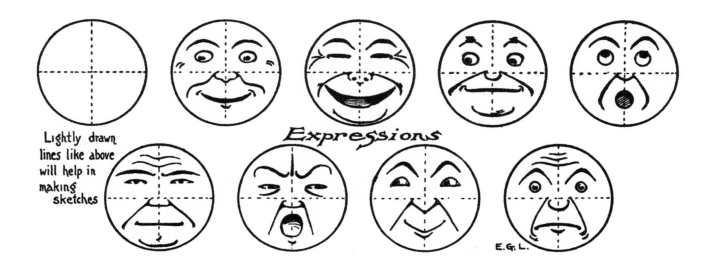

Lightly drawn
lines like above
will help in
making
sketches

Expressions

E.G.L.

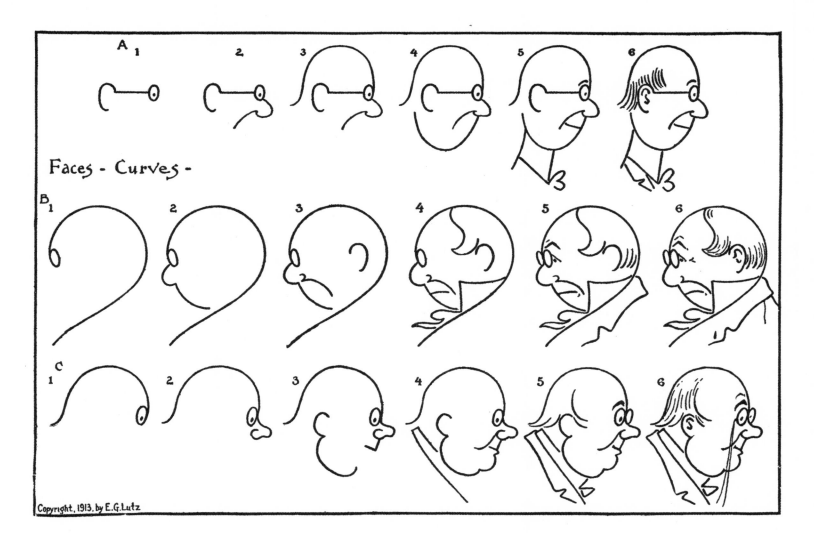

Faces - Curves -

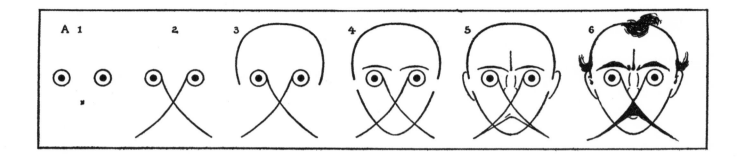

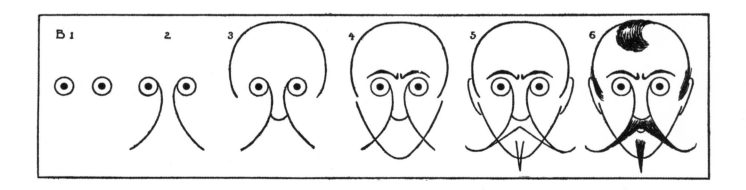

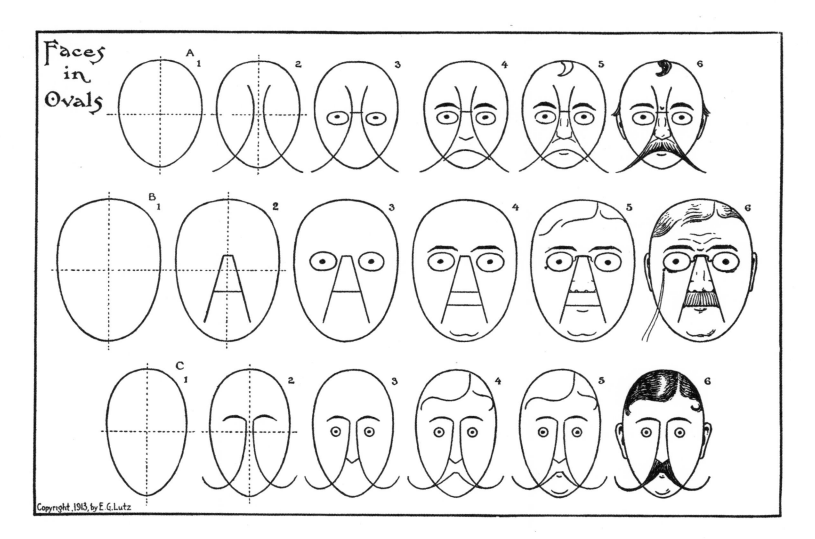

Faces in Ovals

63

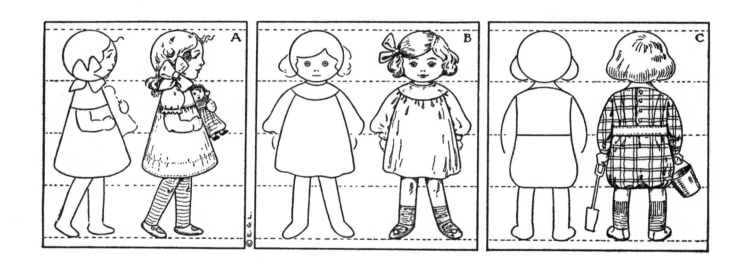

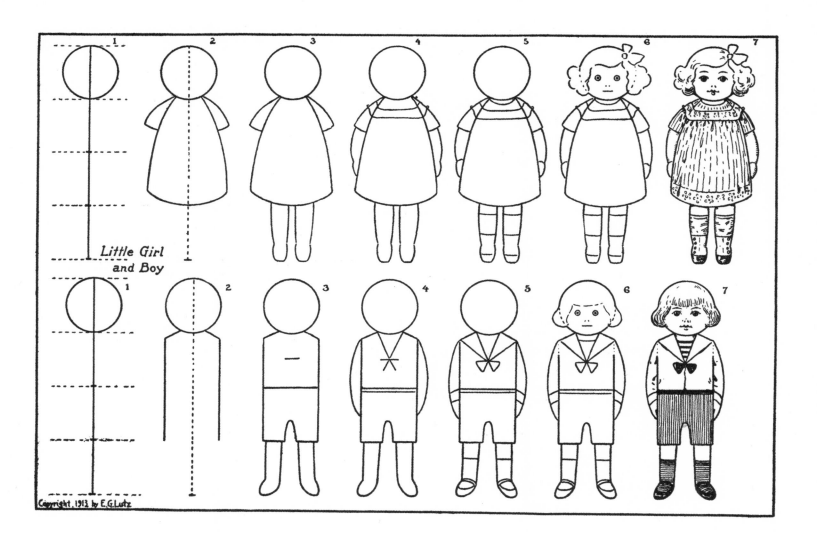

Little Girl and Boy

Copyright, 1913 by E.G.Lutz

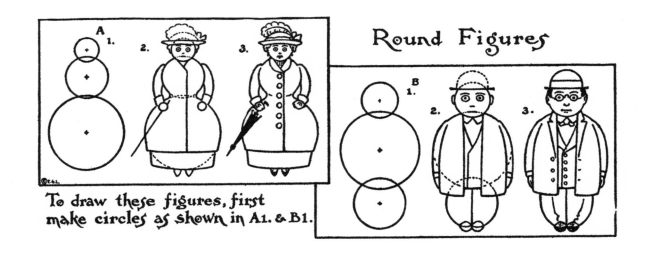

To draw these figures, first
make circles as shown in A1. & B1.

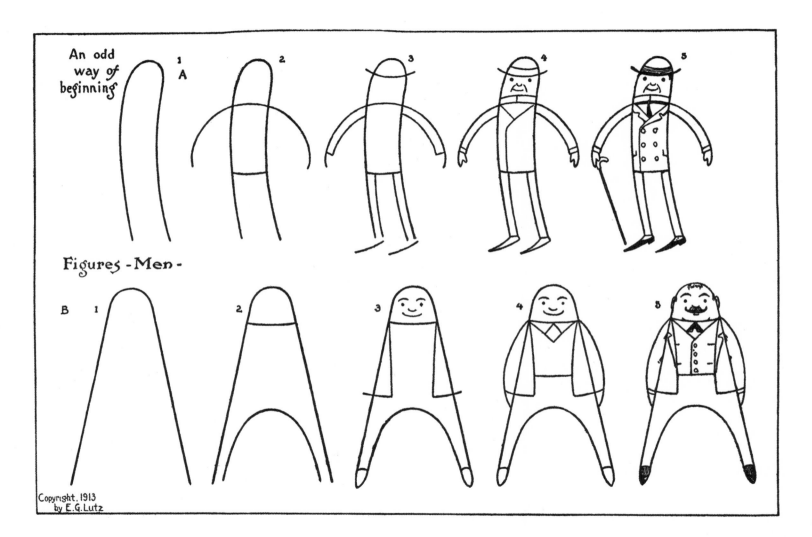

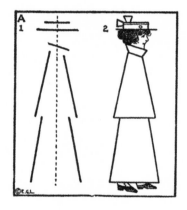
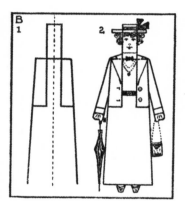
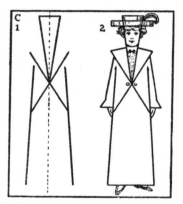
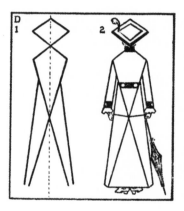

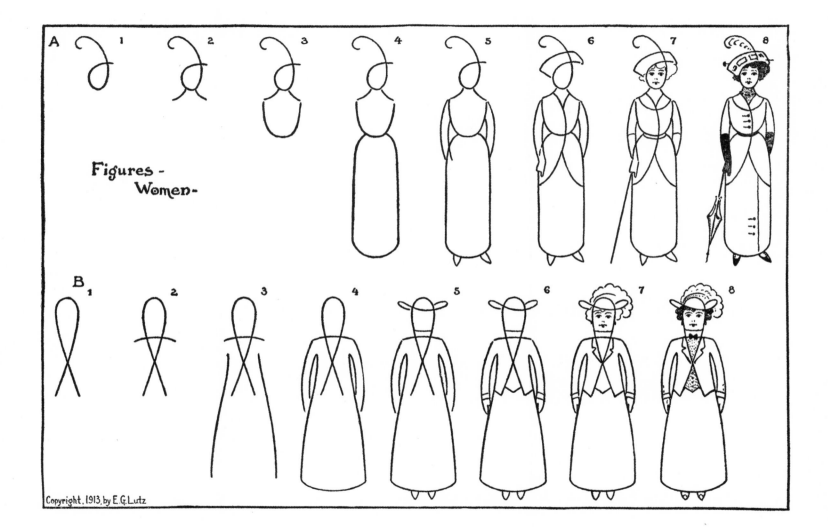

A 1 2 3 4 5 6 7 8

Figures - Women -

B 1 2 3 4 5 6 7 8

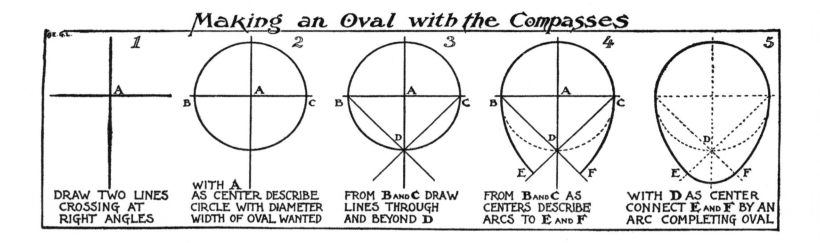

1 DRAW TWO LINES CROSSING AT RIGHT ANGLES

2 WITH A AS CENTER DESCRIBE CIRCLE WITH DIAMETER WIDTH OF OVAL WANTED

3 FROM B AND C DRAW LINES THROUGH AND BEYOND D

4 FROM B AND C AS CENTERS DESCRIBE ARCS TO E AND F

5 WITH D AS CENTER CONNECT E AND F BY AN ARC COMPLETING OVAL

DRAWING OVALS AND ELLIPSES

Take note, first of all, of the difference between an ellipse and an oval.

The large plate explains the construction of an ellipse. It shows how to find the points where the three pins are placed that determine the size of the looped string. Be sure and make measurements accurately. Use a string that will not give, cotton thread is good for small ellipses, silk is too elastic. A suggestion to amateur gardeners: make elliptical flower beds this way.

The caution in regard to accuracy also applies to the making of the oval.

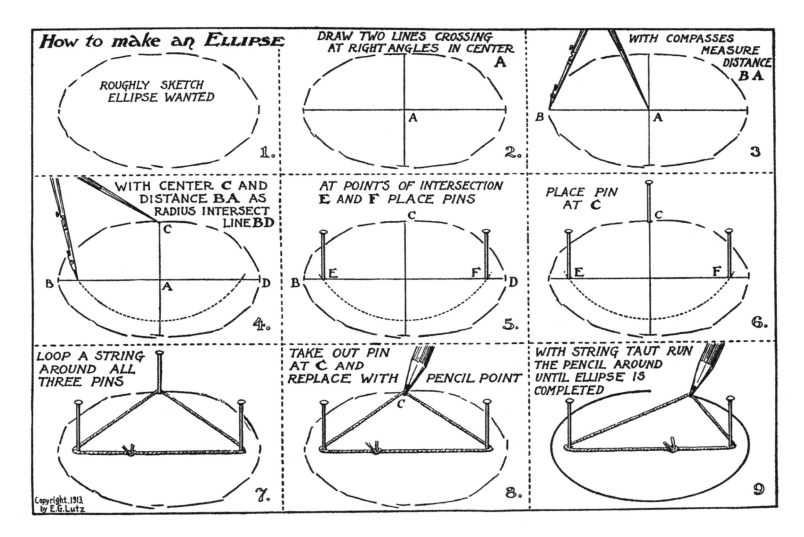

How to make an ELLIPSE

1. ROUGHLY SKETCH ELLIPSE WANTED

2. DRAW TWO LINES CROSSING AT RIGHT ANGLES IN CENTER

3. WITH COMPASSES MEASURE DISTANCE BA

4. WITH CENTER C AND DISTANCE BA AS RADIUS INTERSECT LINE BD

5. AT POINTS OF INTERSECTION E AND F PLACE PINS

6. PLACE PIN AT C

7. LOOP A STRING AROUND ALL THREE PINS

8. TAKE OUT PIN AT C AND REPLACE WITH PENCIL POINT

9. WITH STRING TAUT RUN THE PENCIL AROUND UNTIL ELLIPSE IS COMPLETED

Copyright 1913 by E.G.Lutz

71

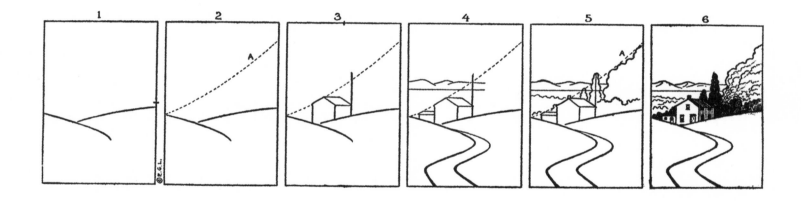

SUGGESTIONS FOR WATER-COLOR PAINTING

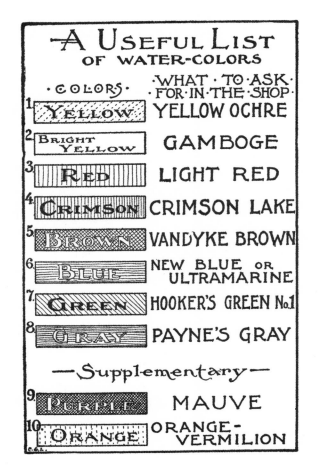

A Useful List of Water-Colors

·COLORS·	·WHAT·TO·ASK· FOR·IN·THE·SHOP·
1 Yellow	YELLOW OCHRE
2 Bright Yellow	GAMBOGE
3 Red	LIGHT RED
4 Crimson	CRIMSON LAKE
5 Brown	VANDYKE BROWN
6 Blue	NEW BLUE or ULTRAMARINE
7 Green	HOOKER'S GREEN No.1
8 Gray	PAYNE'S GRAY
— Supplementary —	
9 Purple	MAUVE
10 Orange	ORANGE-VERMILION

Here is a good list of colors for practical work. **The first eight are enough for every purpose;** but add, if you wish, purple and orange. Moist colors in pans are best. There are many different kinds of red, green, blue and brown paints; and as you may be puzzled and not know what to get, the names of the best hues of these particular colors are also given. The most useful paints in this list are yellow ochre, light red, Vandyke brown and Payne's gray. Learn to work with them, use them often and see the beautiful effects they produce. Delicate tints are made with thin washes of yellow ochre and light red. Vandyke brown makes a variety of pleasing tints.

Use the bright colors sparingly.

You do not need a black paint. Payne's gray with either brown, blue, crimson or green gives rich dark tones. Payne's gray is also useful in shadows and shading other colors. For the different kinds of greens, mix yellow ochre, blue or brown with Hooker's green. Use thin washes of light red and blue for the gray of distances and clouds.

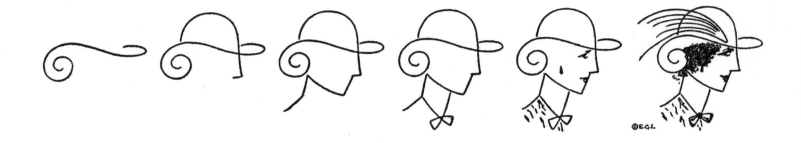

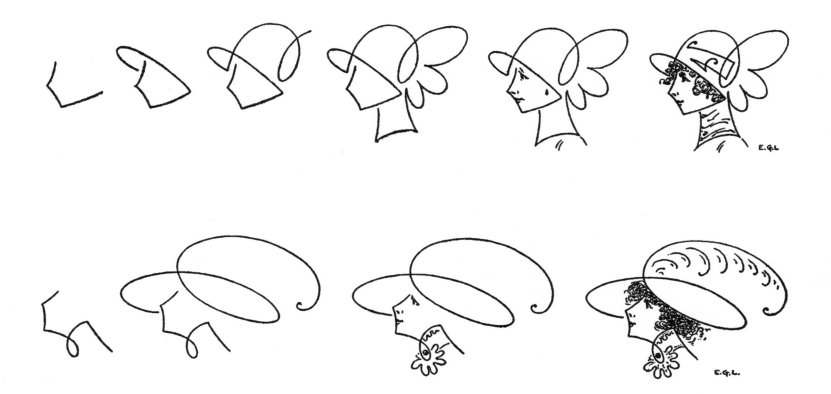

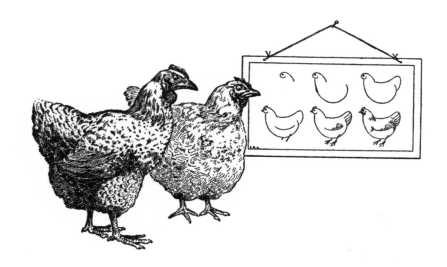

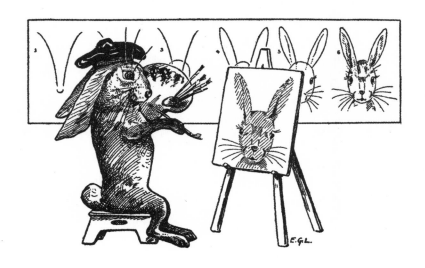

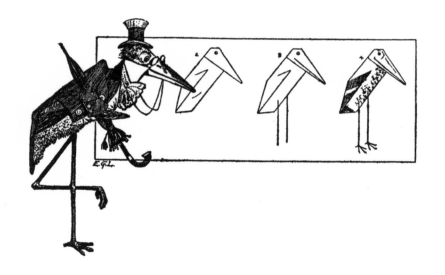

First published in 1913
This facsimile edition first published in Great Britain in 2015 by LOM Art, an imprint of
Michael O'Mara Books Limited
9 Lion Yard
Tremadoc Road
London SW4 7NQ

A CIP catalogue record for this book is available from the British Library.

Papers used by Michael O'Mara Books Limited are natural, recyclable products made from wood grown in sustainable forests. The manufacturing processes conform to the environmental regulations of the country of origin.

ISBN: 978-1-91055-203-2 in hardback print format

7 8 9 10

Follow us on Twitter @OMaraBooks

www.mombooks.com

Printed and bound in China